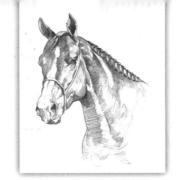

Horses

From the earliest cave drawings to the modern masters, artists have long been inspired by the horse as a subject. Horses have an elegance and spirit that we're naturally attracted to and intrigued by. With their fluid lines, powerful muscles, and graceful motions, it's no wonder that these extraordinary creatures have frequently been celebrated by artists throughout the ages. And now you can learn to draw horses too, even if you've never picked up a drawing pencil. In this book, you'll find the basics of horse anatomy and correct proportion, as well as special tips for drawing facial features, ears, hooves, and manes. You'll also learn how to render these beautiful and expressive animals in exciting action poses—racing, jumping, and galloping. Just follow the simple steps in this book, and soon you'll develop your own style for drawing these magnificent animals.

CONTENTS

Getting Started	Clydesdale
Shading Techniques	Circus Horse19
Anatomy & Proportion	Arabian
Eyes & Muzzles 6	Shetland Pony
Ears & Hooves	Horse & Rider in Action
Basic Heads	The Gallop24
Advanced Heads	The Jump
Foal's Body	Polo Pony & Player
Adult Horse's Body	Racehorse & Jockey
Quarter Horse	Western Horse & Rider

attamco

urpis

Getting Started

Drawing is just like writing your name. You use lines to make shapes. In the art of drawing, you carry it a bit further, using shading techniques to create the illusion of three-dimensional form.

Only a few basic tools are needed in the art of drawing. The tools necessary to create the drawings in this book are all shown here.

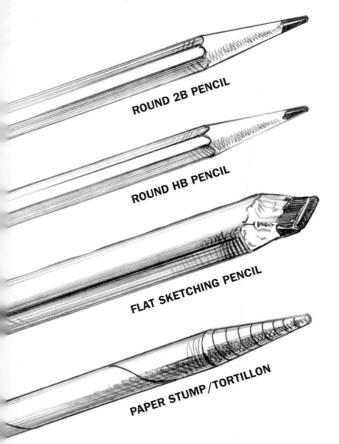

Pencils

Pencils come in varying degrees of lead, from very soft to hard (e.g., 6B, 4B, 2B, and HB, respectively). Harder leads create lighter lines and are used to make preliminary sketches. Softer leads are usually used for shading.

Flat sketching pencils are very helpful; they can create wide or thin lines, and even dots. Find one with a B lead, the degree of softness between HB and 2B.

Although pencil is the primary tool used for drawing, don't limit yourself. Try using charcoal, Conté crayons, brush and ink, or pastels—they can add color and dimension to your work.

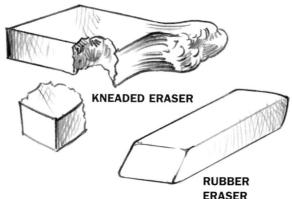

Erasers

Erasers are not only useful for correcting mistakes, they are also fine drawing tools. Choose from several types: kneaded, vinyl, gum, or rubber, depending on how you want to use the eraser. For example, you can mold a kneaded eraser into a point or break off smaller pieces to lift out highlights or create texture. A gum or rubber eraser works well for erasing larger areas.

Paper

Paper varies according to color, thickness, and surface quality (e.g., smooth or rough). Use a sketch pad for practice. For finer renderings, try illustration or Bristol board. As you become more comfortable with drawing techniques, experiment with better quality paper to see how it affects your work.

Other Helpful Materials

You should have a paper blending stump (also known as a *tortillon*) for creating textures and blends in your drawing. It enhances certain effects and, once covered with lead, can be used to draw smeared lines.

In order to conserve your lead, have some sandpaper on hand so you can sharpen the lead without wearing down the pencil. You may want to buy a metal ruler as well, for drawing straight lines. Finally, a sturdy drawing board provides a stable surface for your drawing.

Final Preparations

Before you begin drawing, set up a spacious work area that has plenty of natural light. Make sure all your tools and materials are easily accessible from where you're sitting. Since you might be sitting for hours at a time, find a comfortable chair.

If you wish, tape the paper at the corners to your drawing board or surface to prevent it from moving while you work. You can also use a ruler to make a light border around the edge of the paper; this will help you use the space on your paper wisely, especially if you want to frame or mat the finished product.

This is an oval shape.

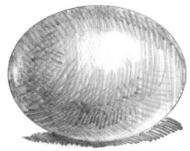

This has a three-dimensional, ball-like form.

As you read through this book, carefully note how the words *shape* and *form* are used. *Shape* refers to the actual outline of an object, while *form* refers to its three-dimensional appearance.

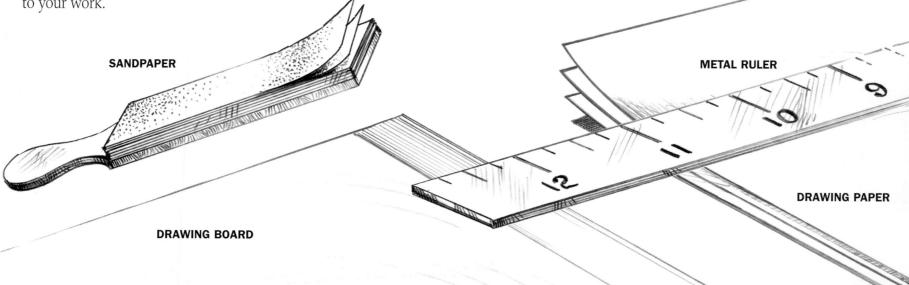

Shading Techniques

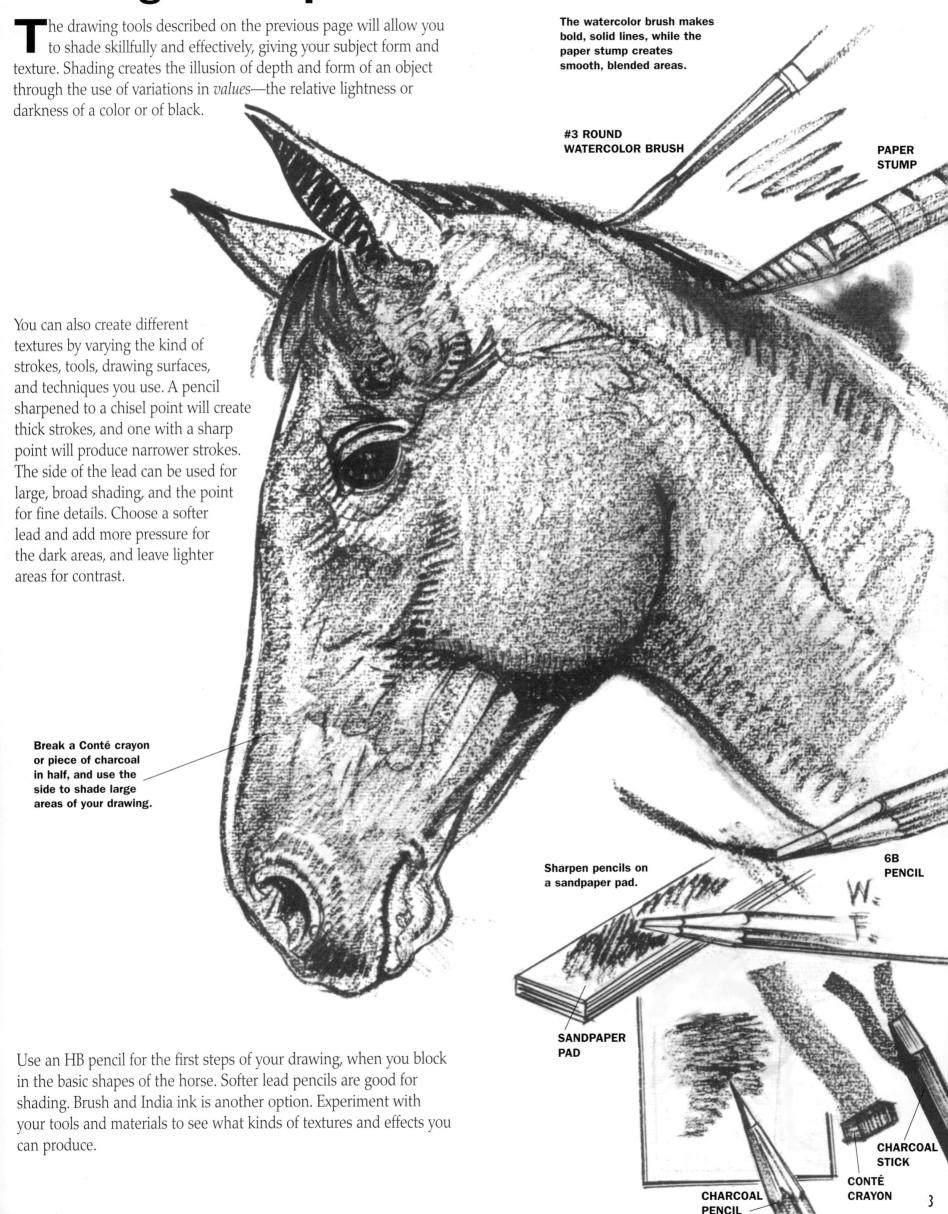

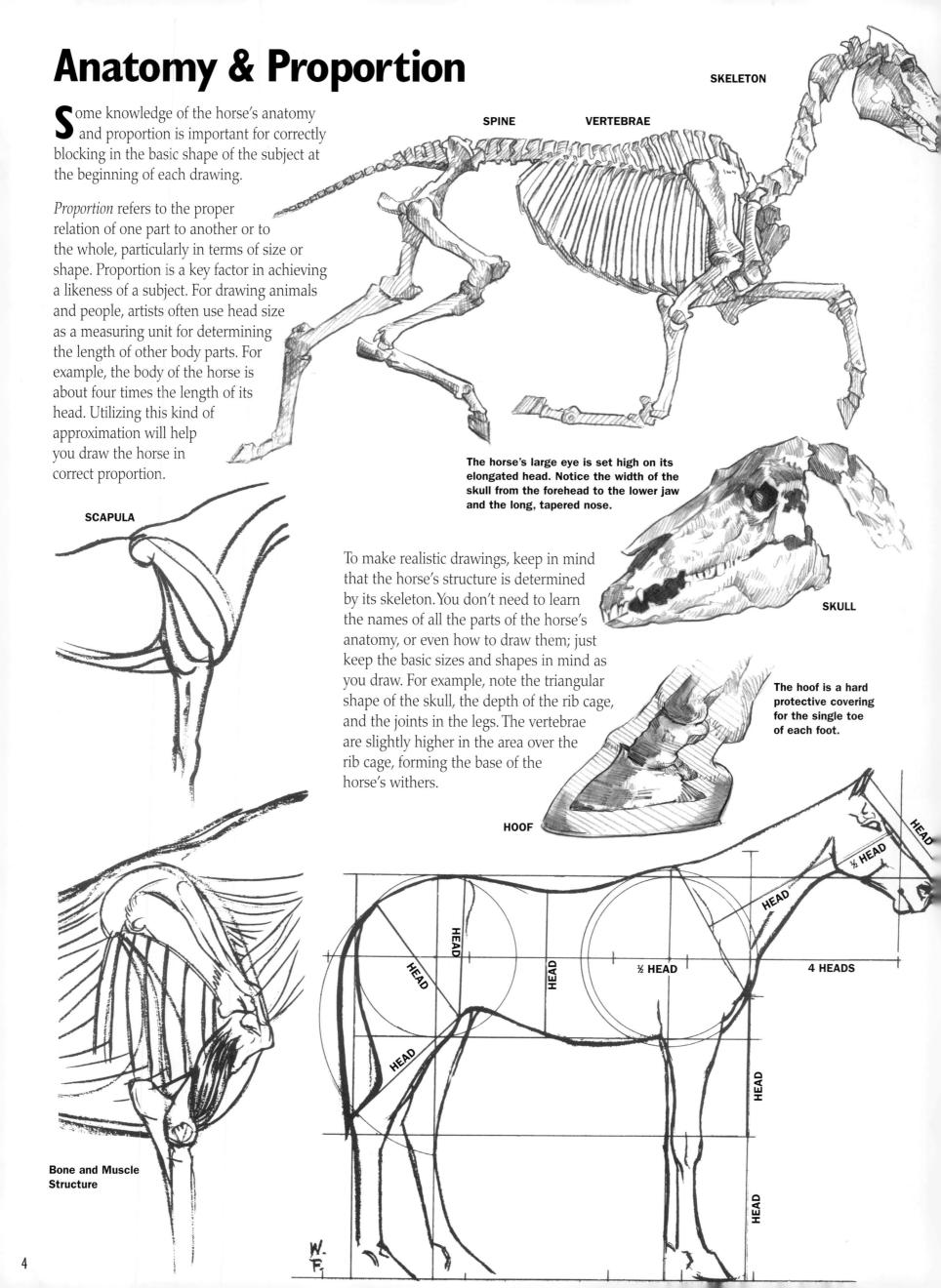

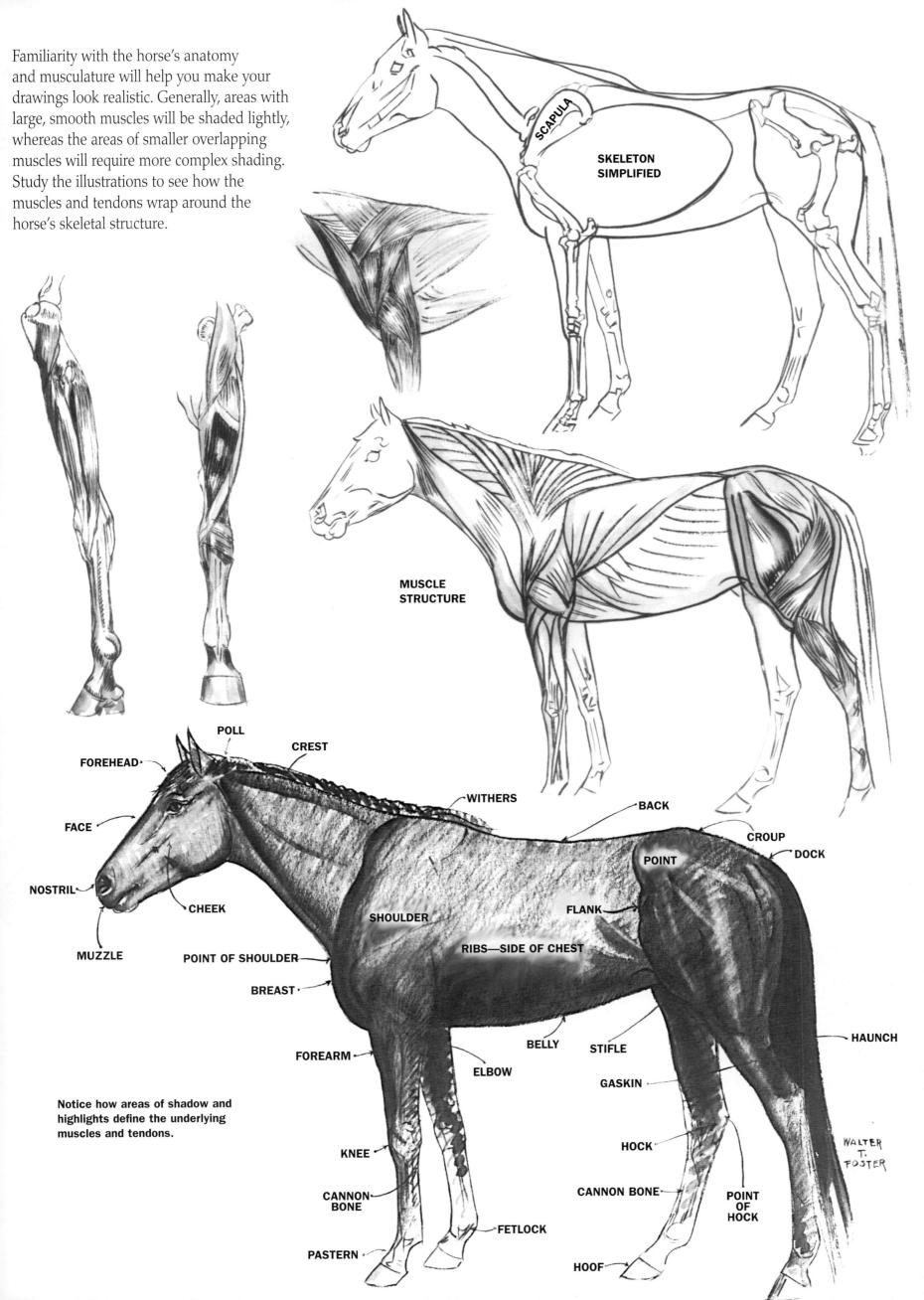

acial features, such as eyes and muzzles, are a good place to start learning to draw horses. If you are a beginner, you might want to practice drawing the parts separately before attempting a complete rendering. Study the drawings on this page, and look at the way the shapes and forms change as the viewing angle changes.

Practice by making many sketches of these features from several different angles. Copy the examples here, or use your own models. Often, details, such as the expression in the eve or the shading around the nostril, are what separate an average drawing from a remarkable one. Start by sketching the general shape with an HB pencil, and then refine the lines until you are satisfied.

Remember that the eveball is a sphere, so the eyelid covering it will also be spherical in shape.

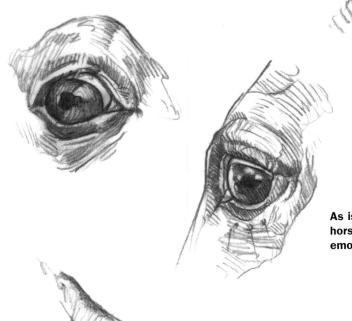

As is true for all mammals, horses' eyes reveal their emotions and personality.

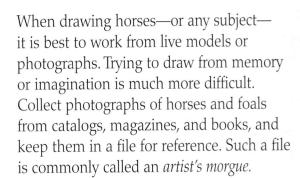

The forms of the muscles, veins, and tendons are also easily discernible under the surface of the horse's skin and sleek coat.

Ears & Hooves

The position of the horse's ears reveals its mood. For example, ears pricked forward usually indicate alert interest, whereas ears laid back are a sign of anger, discomfort, or fear. As you practice drawing the ears in different positions, note how shading is

used to define the form.

Vary the direction of your pencil strokes to delineate the round form of the ear.

The hoof is a hard covering that encloses the underlying toe bone. The frog is the softer, more tender area in the bottom of the hoof. Notice that the hoof is longer in front and shorter in back; make sure your drawings reflect the proper angle of the hoof. Use parallel strokes (hatching) to emphasize the upright position of these alert ears.

Horseshoes are nailed into the outer hoof wall, but the horse feels no pain because the wall has no nerve endings—just as it doesn't hurt when you trim your fingernails.

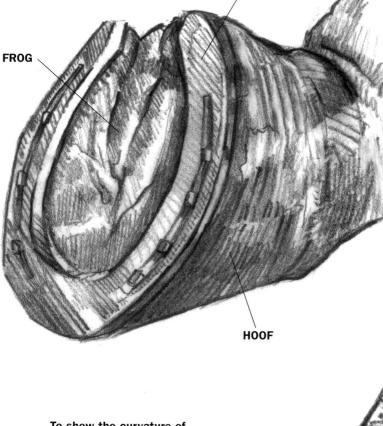

SHOE

To show the curvature of the hoof, use varying values of light and dark. Be sure to leave a highlight where the light strikes the hoof.

Basic Heads

he proportions of this young foal are slightly different from those of the adult horse on the opposite page. It is also shown at a slight three-quarter angle.

In steps A and B, start with the three basic guideline strokes to establish the size and to enable you to see the first stroke while you make the second, to ensure that your proportions are accurate. Follow the right-

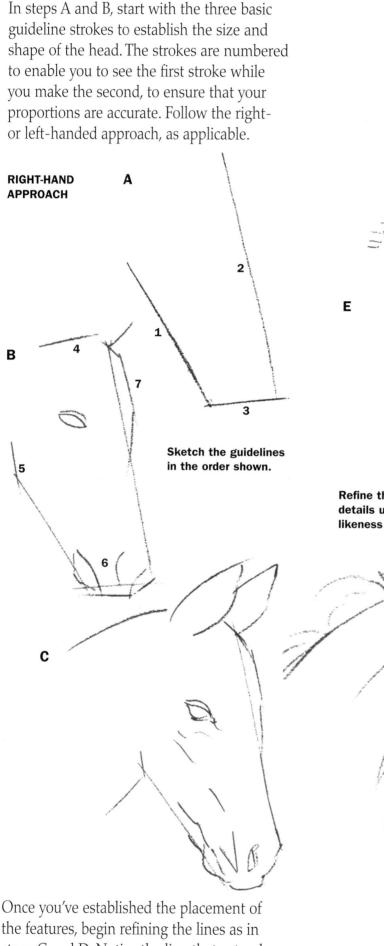

Once you've established the placement of the features, begin refining the lines as in steps C and D. Notice the line that extends along the face in step D; this line defines the top plane from the side plane, giving the head a three-dimensional appearance. Continue adding details until you are satisfied. If you wish, add some shading to enhance the form.

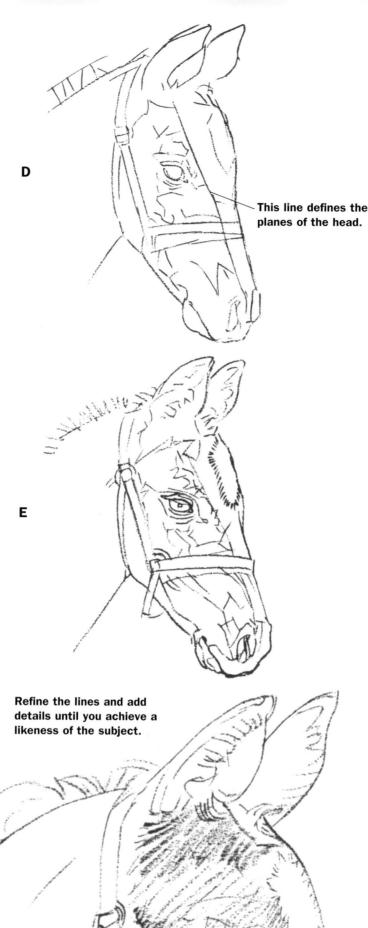

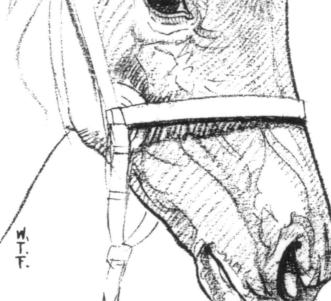

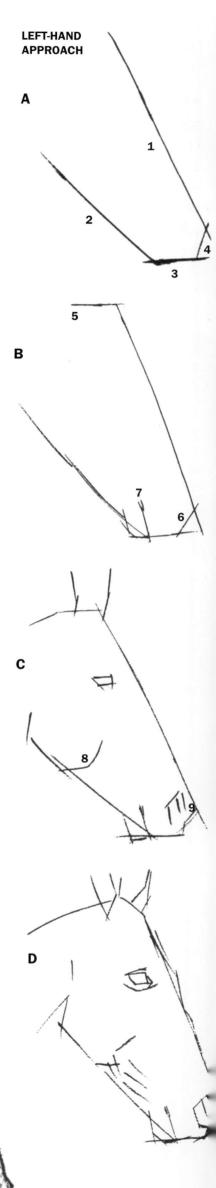

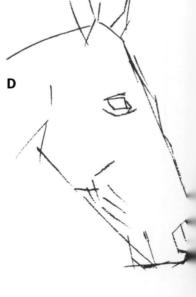

Lightly suggest the muscles lying just beneath the skin.

Although horses' heads all have a similar basic shape, there are variations among breeds and between individual horses. The drawing here is of a classic thoroughbred profile, with a straight nose and slightly tapered muzzle. Practice drawing many different profiles, and see if you can bring out the unique characteristics in each one.

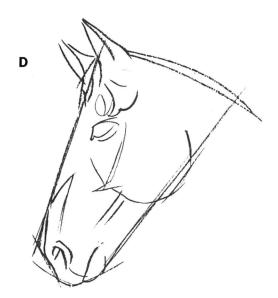

In steps A and B, use an HB pencil to block in a few basic guidelines to establish the placement and general proportion of the head. Then sketch in the outline of the ears and cheek, and block in the position of the eye, nostril, and mouth, as in step C. When you're comfortable with the outline, round out the muzzle, define the features, and suggest the underlying muscles, as shown in steps D and E.

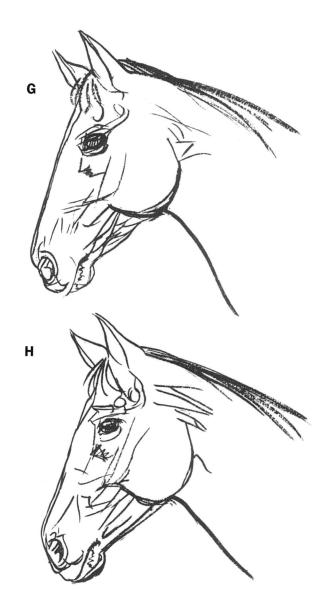

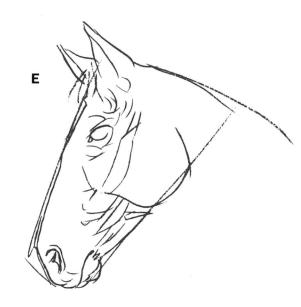

In the final steps, study your reference before further refining the shapes and adding the details. Make note of the length and position of the ears, the angle of the neck, and the curve of the nose and lower lip. Look for the point where the lines of the neck and lower jaw meet the cheek. As your observation skills improve, so will your drawings!

Don't worry about making a final rendering at this point. While working out proportions and improving your observation skills, keep the drawings loose and sketchy. You can focus on shading techniques later.

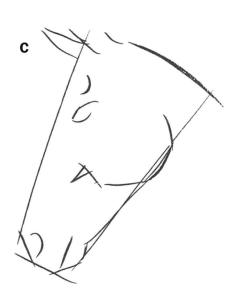

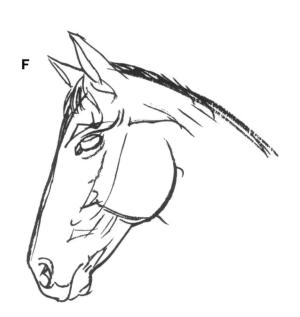

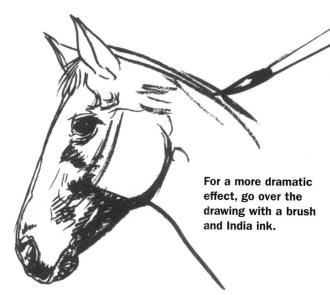

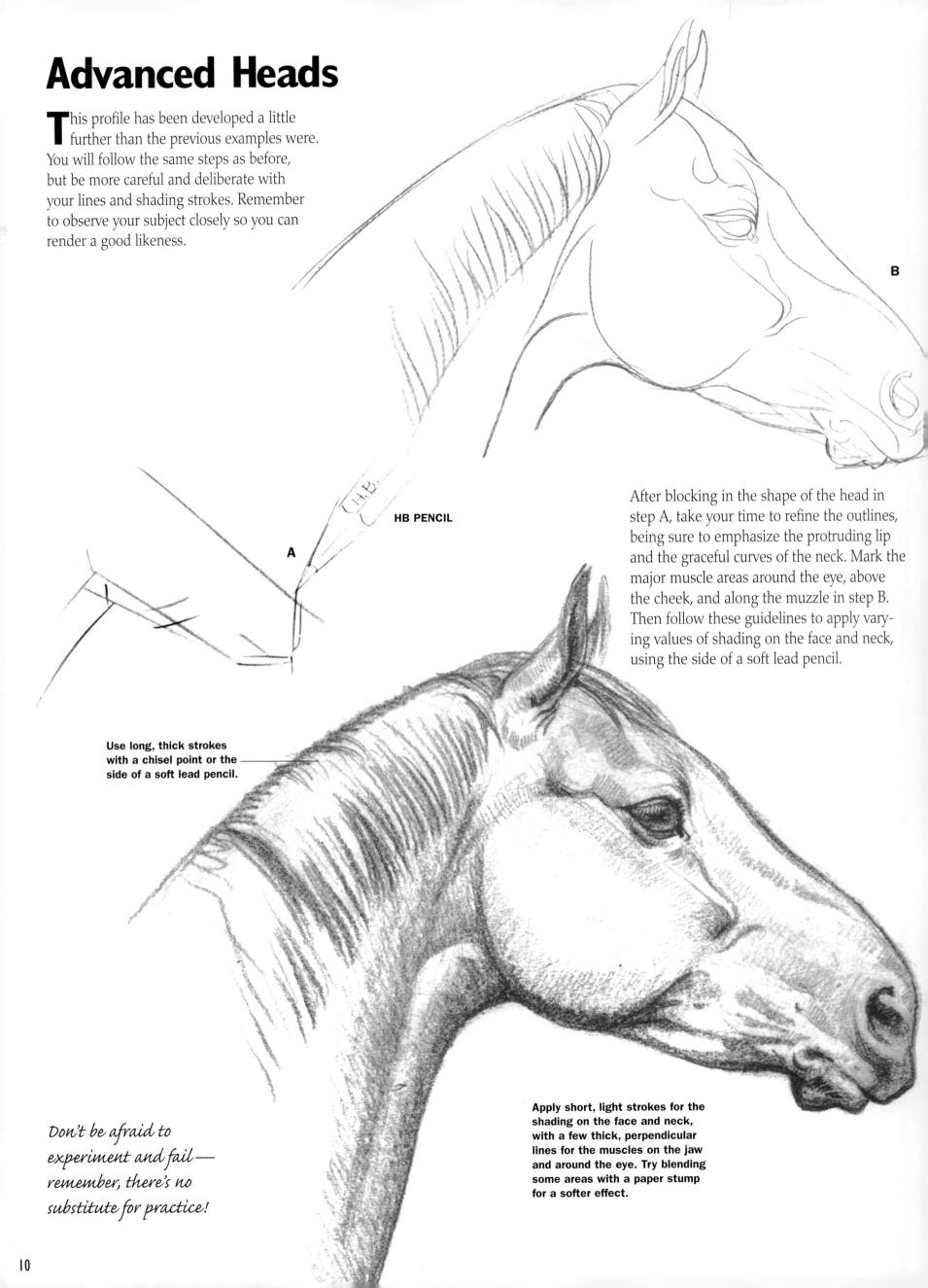

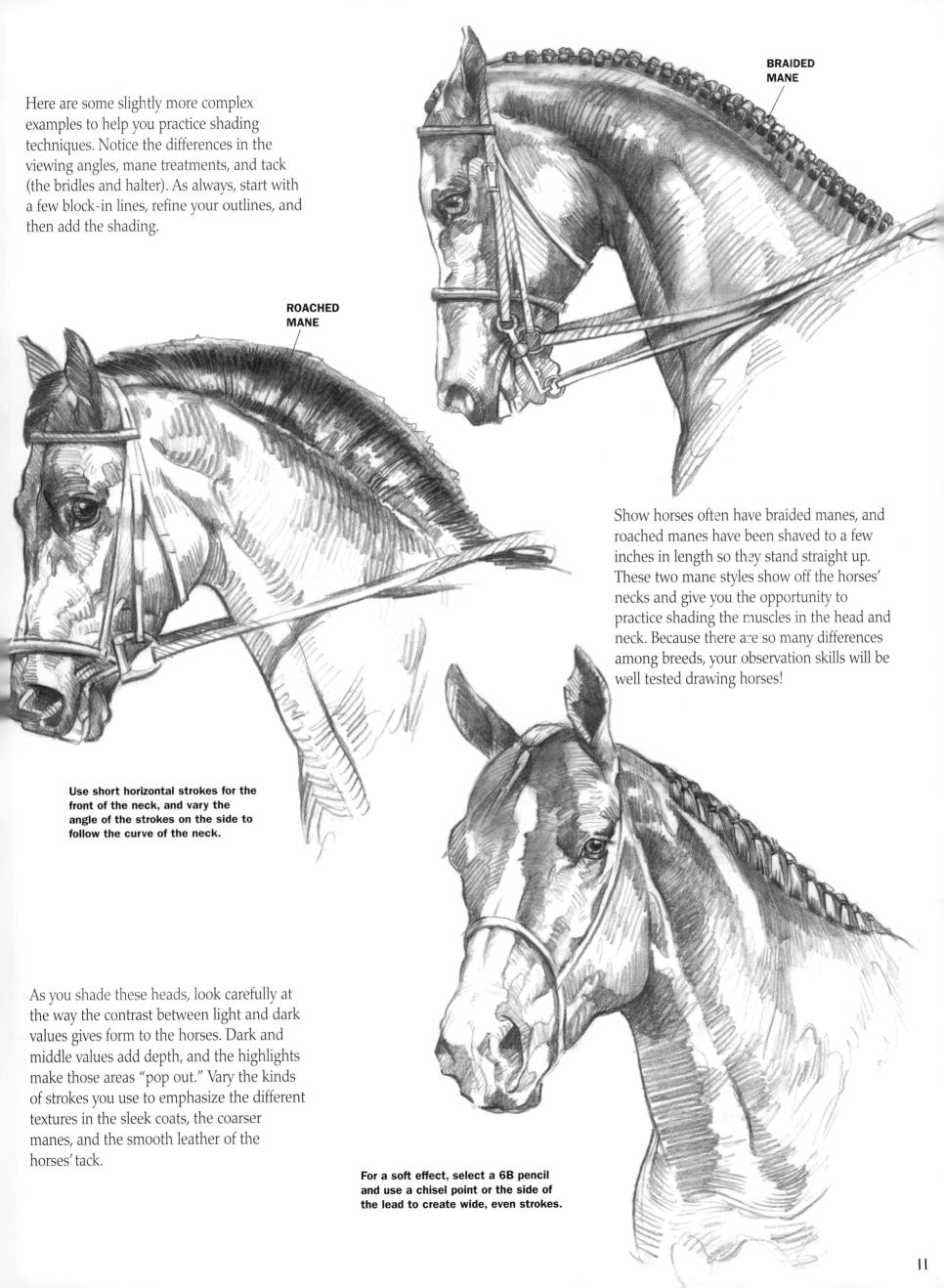

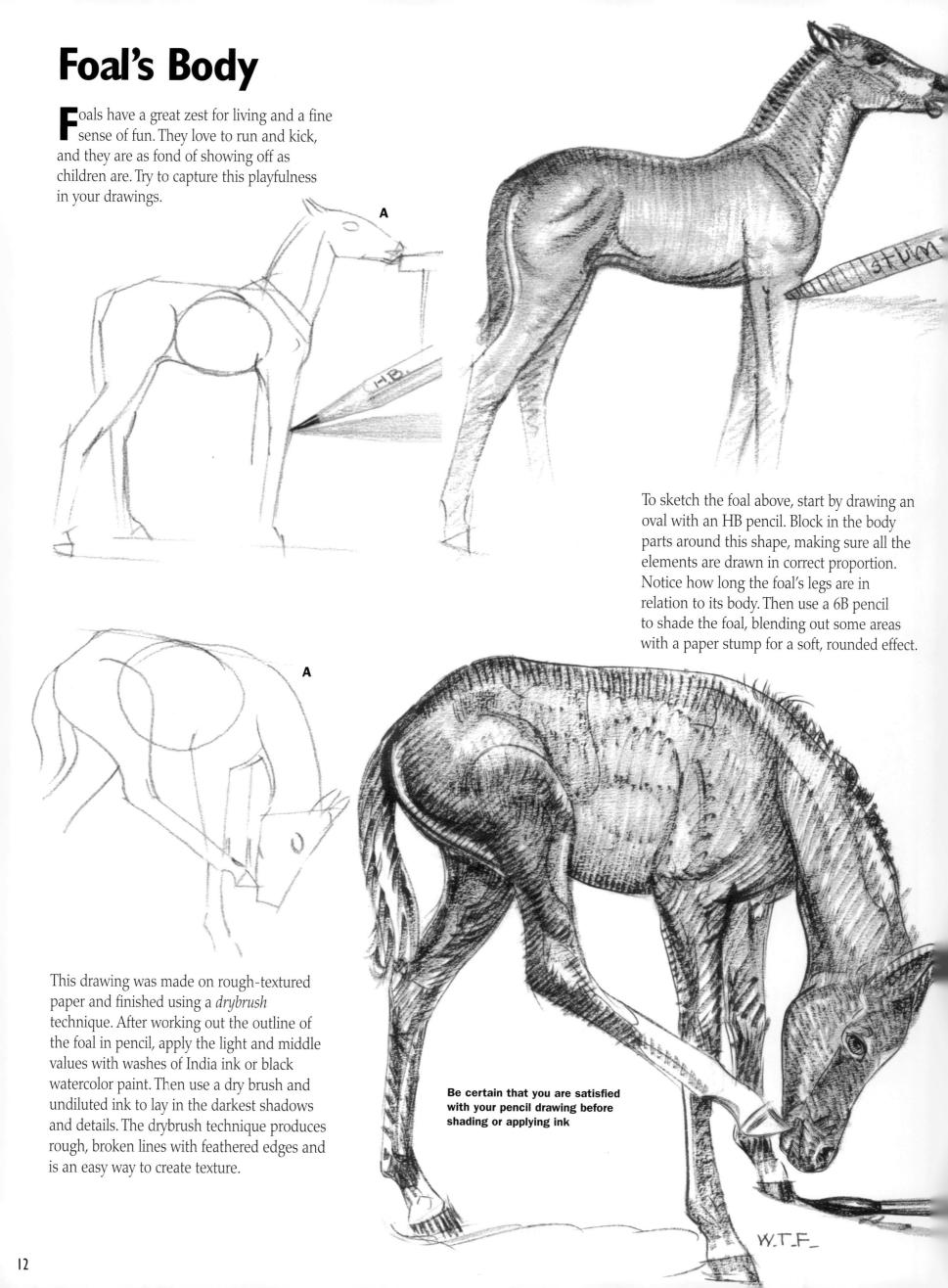

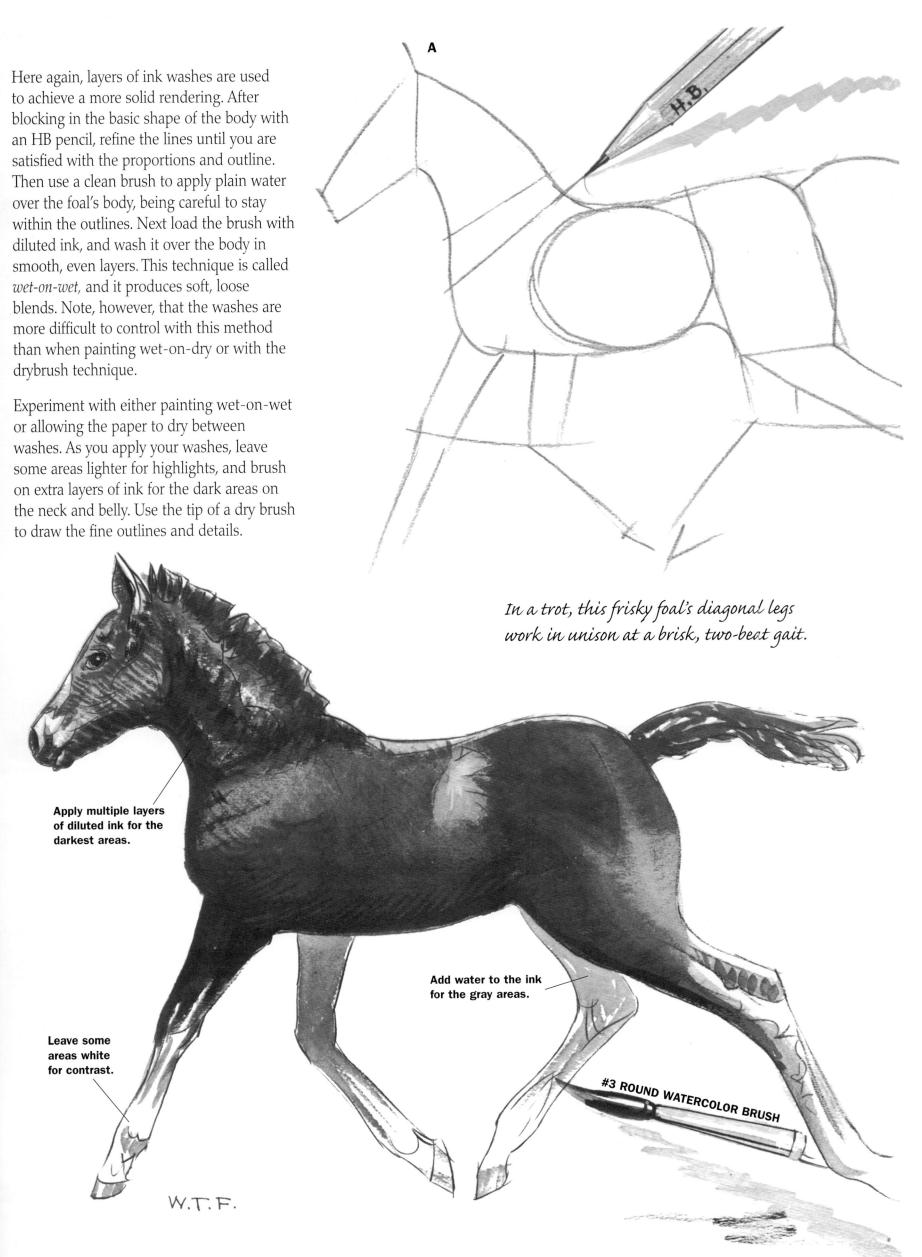

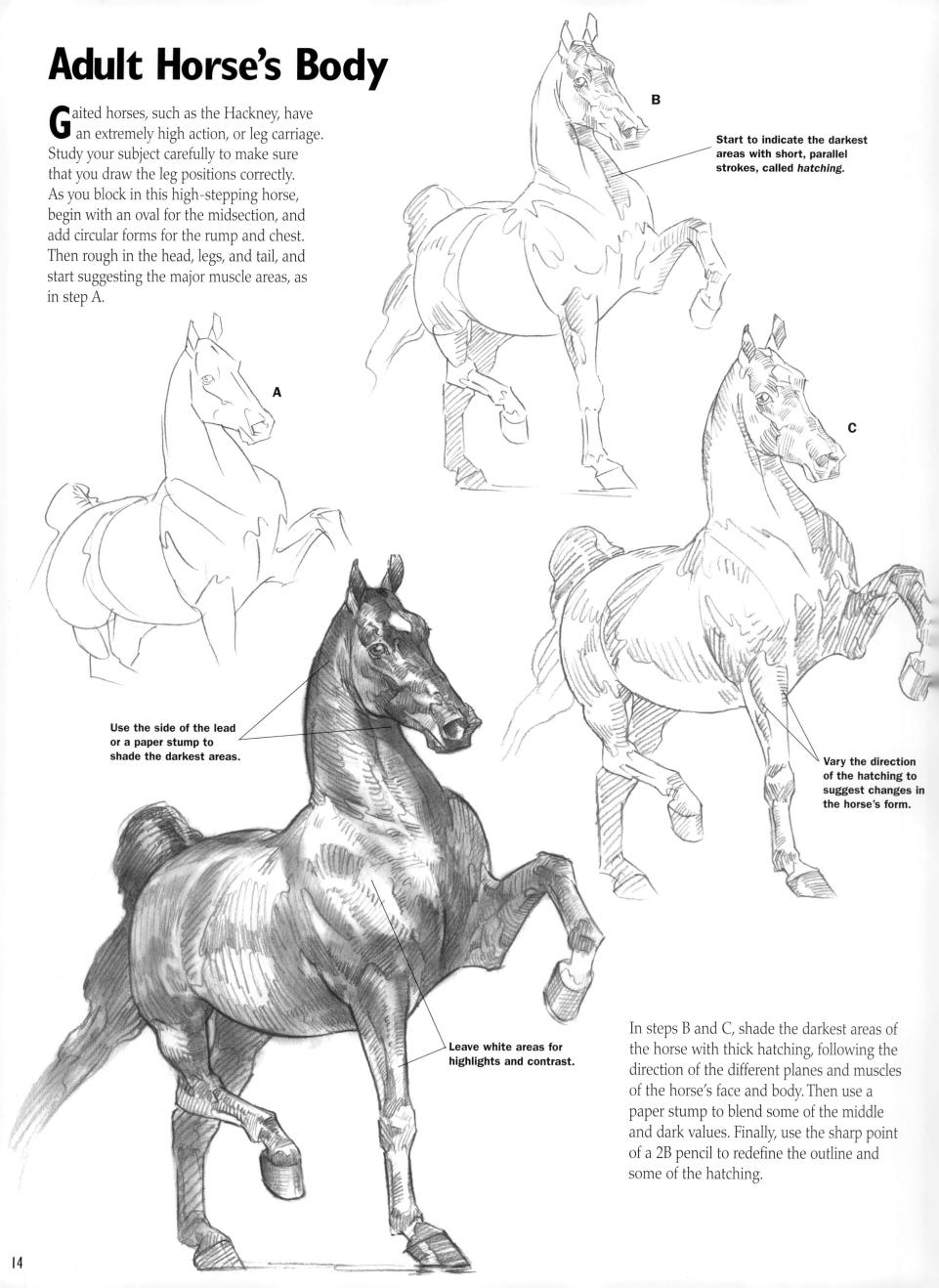

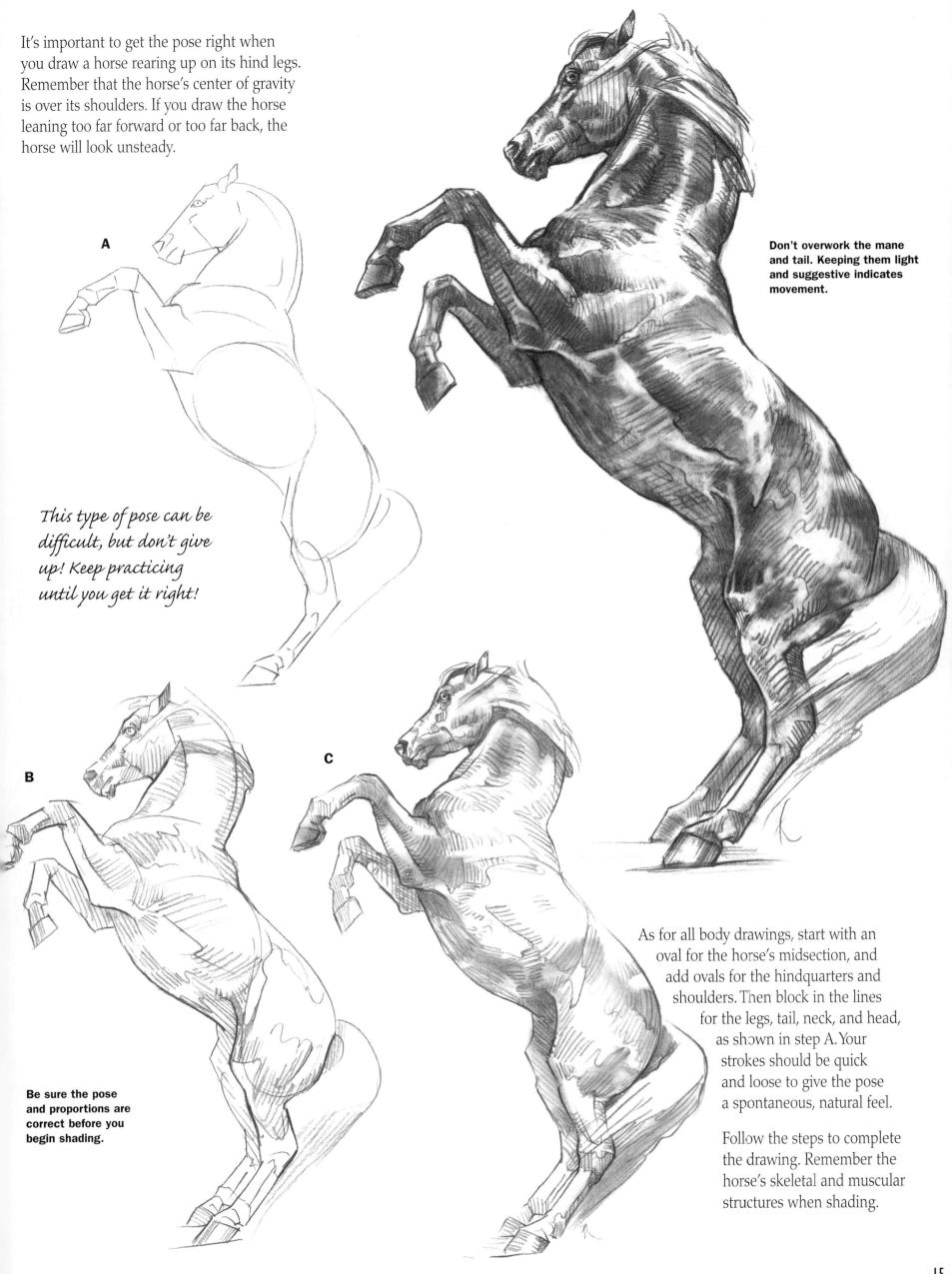

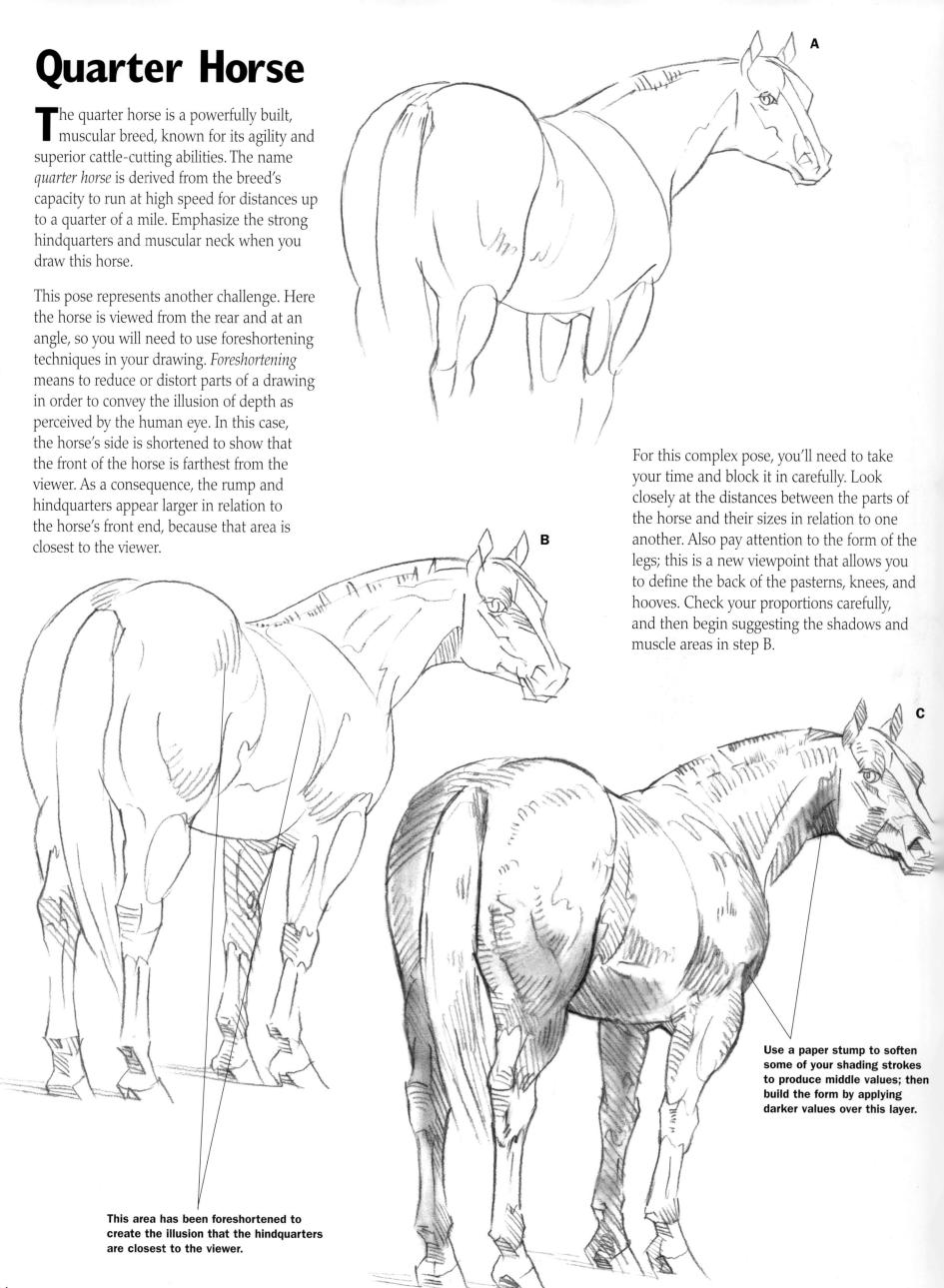

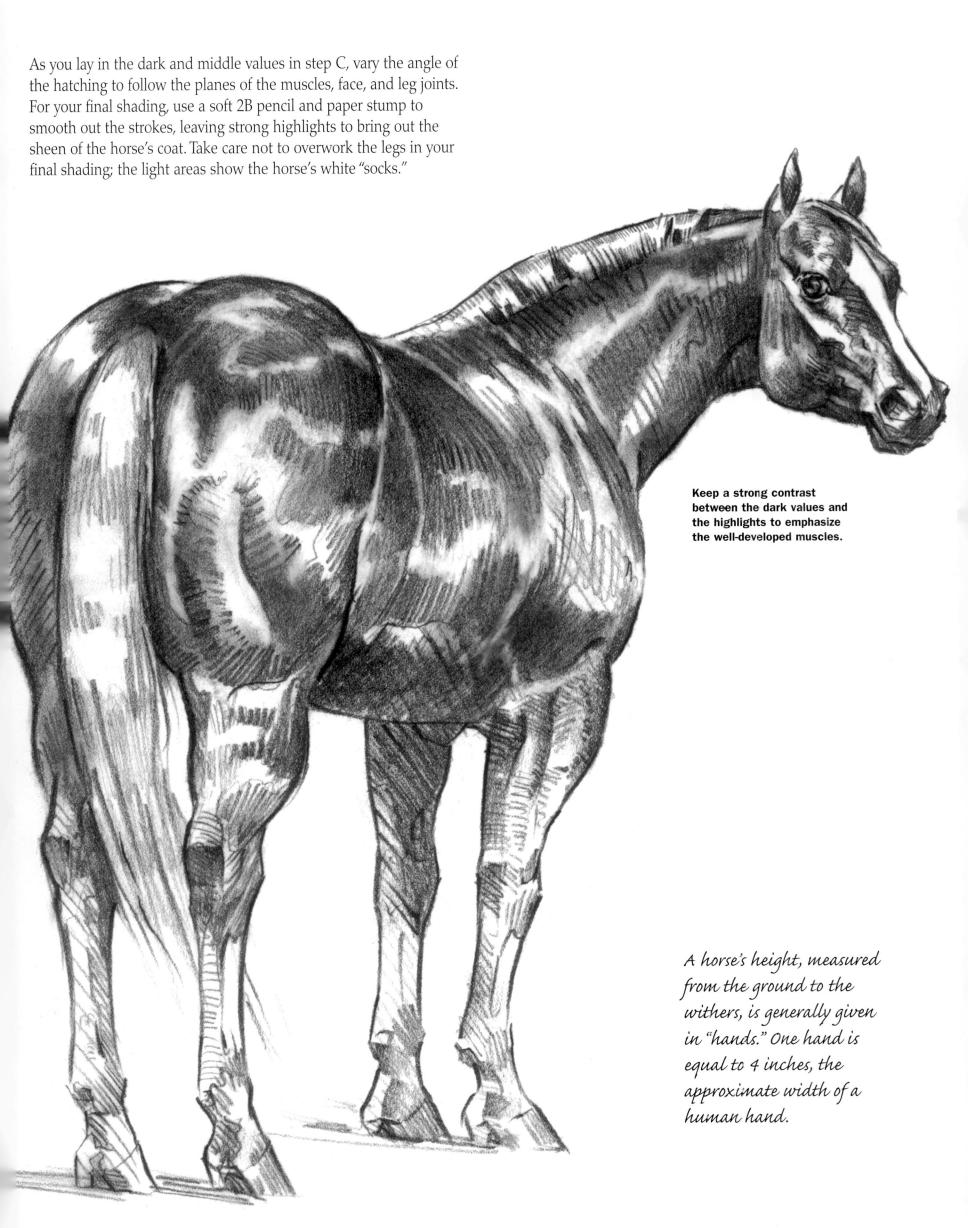

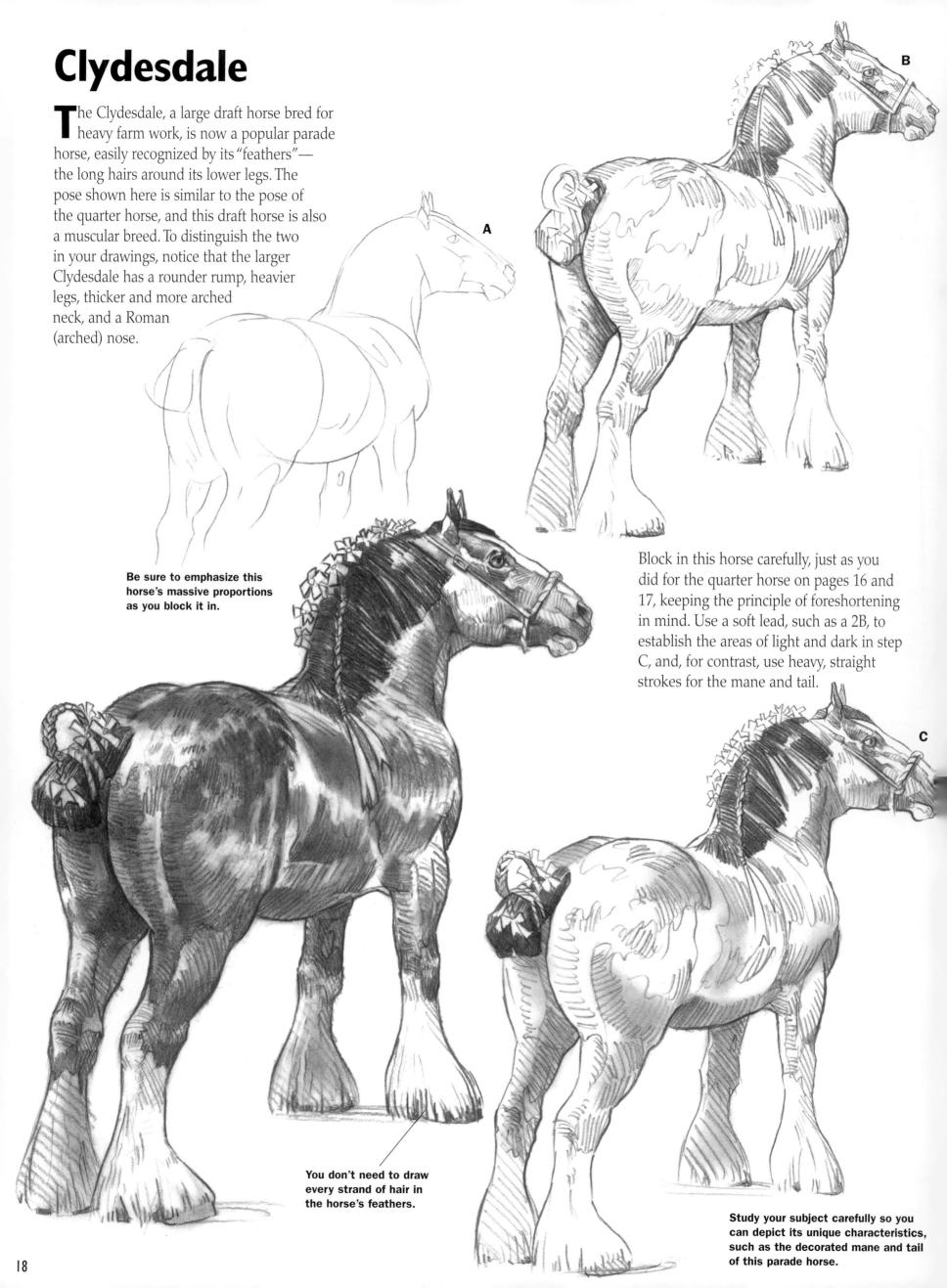

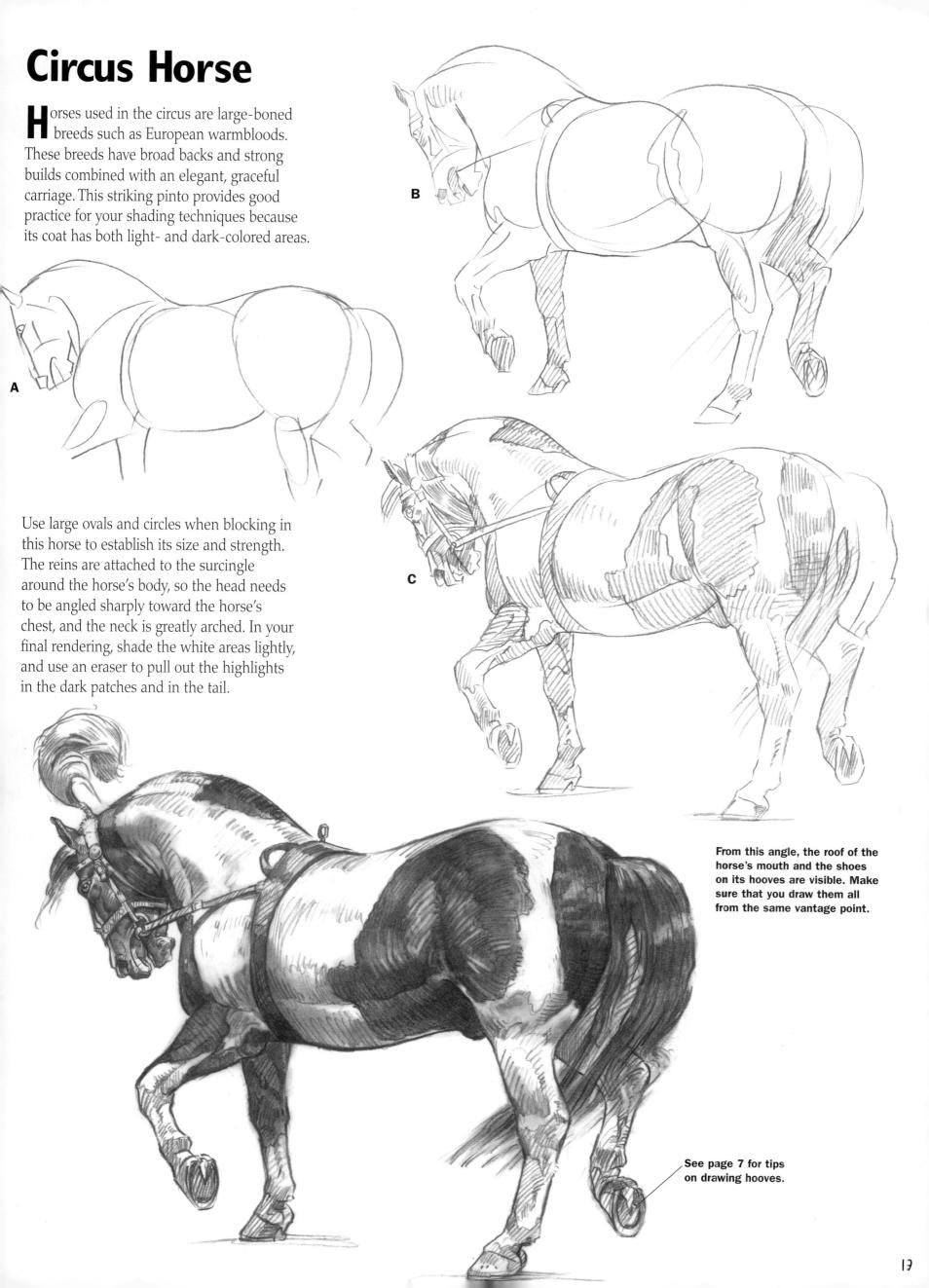

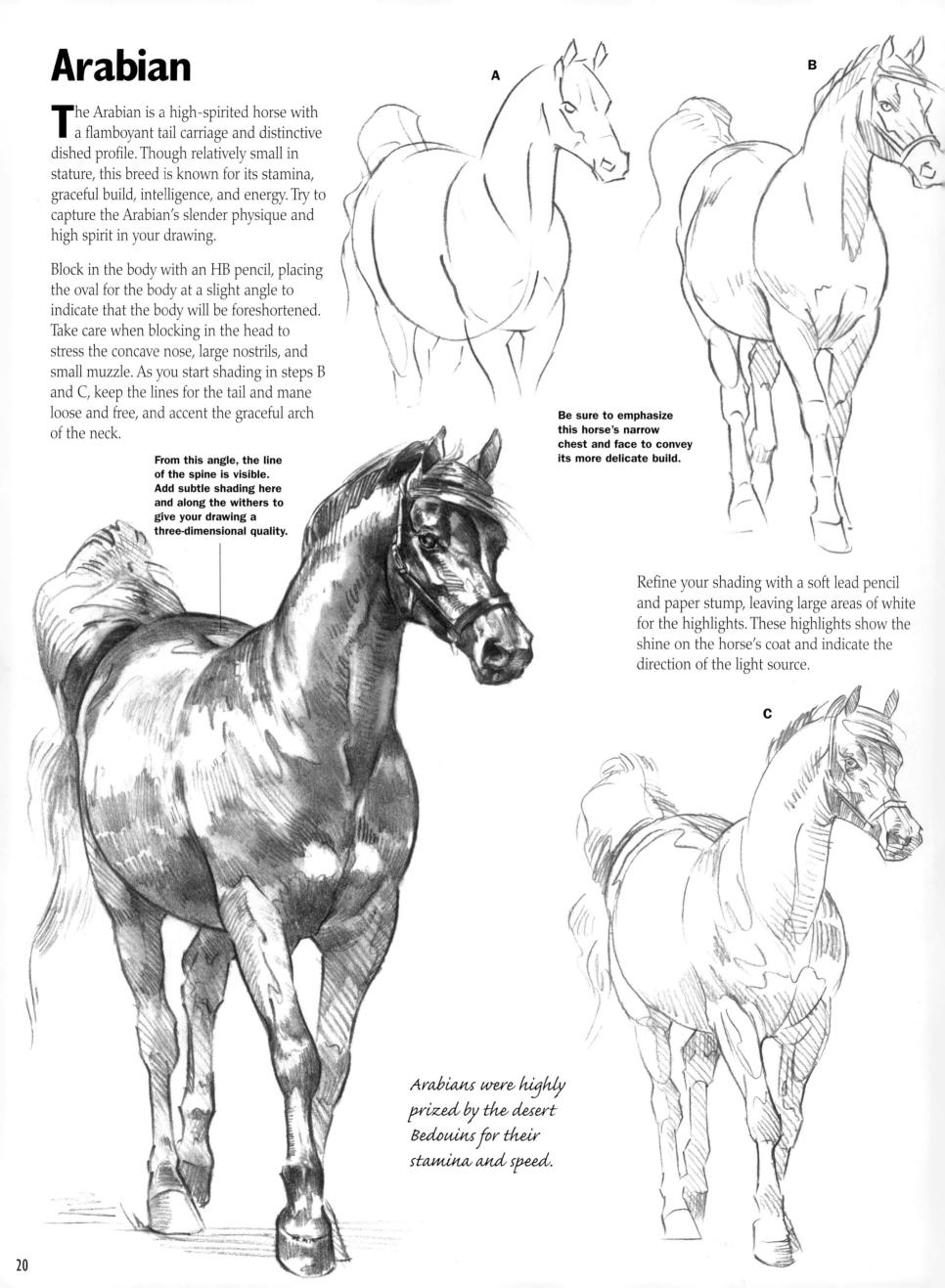

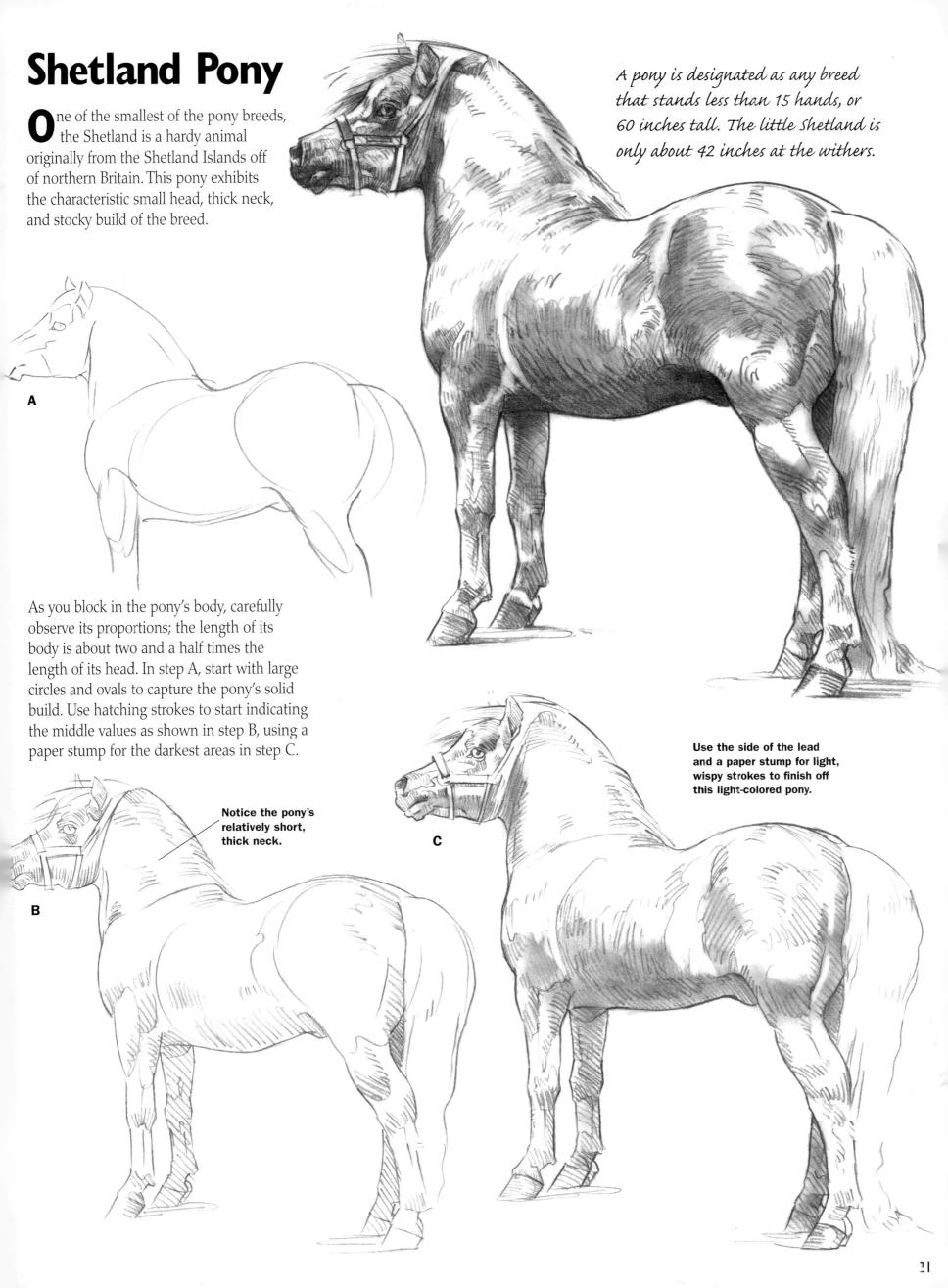

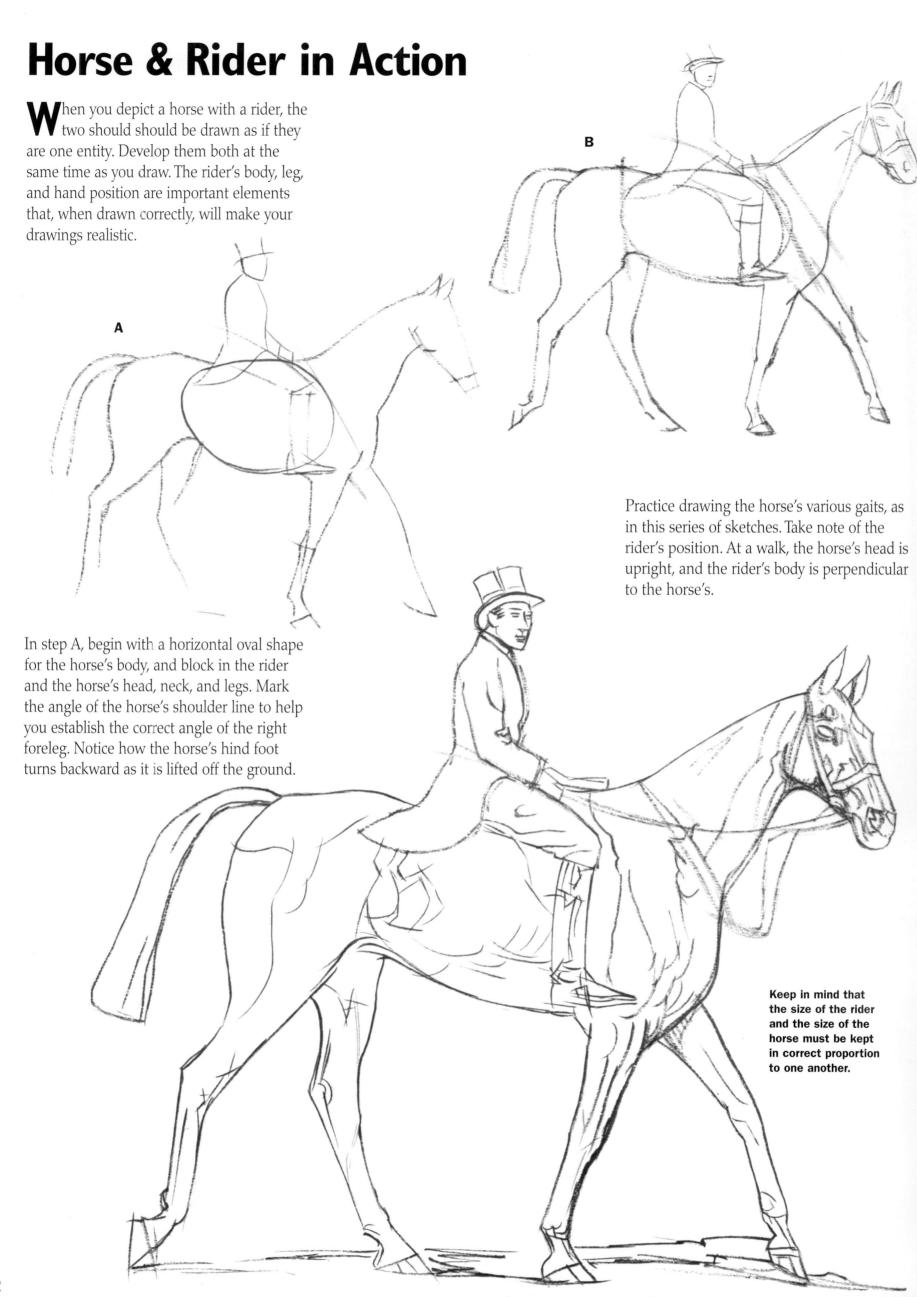

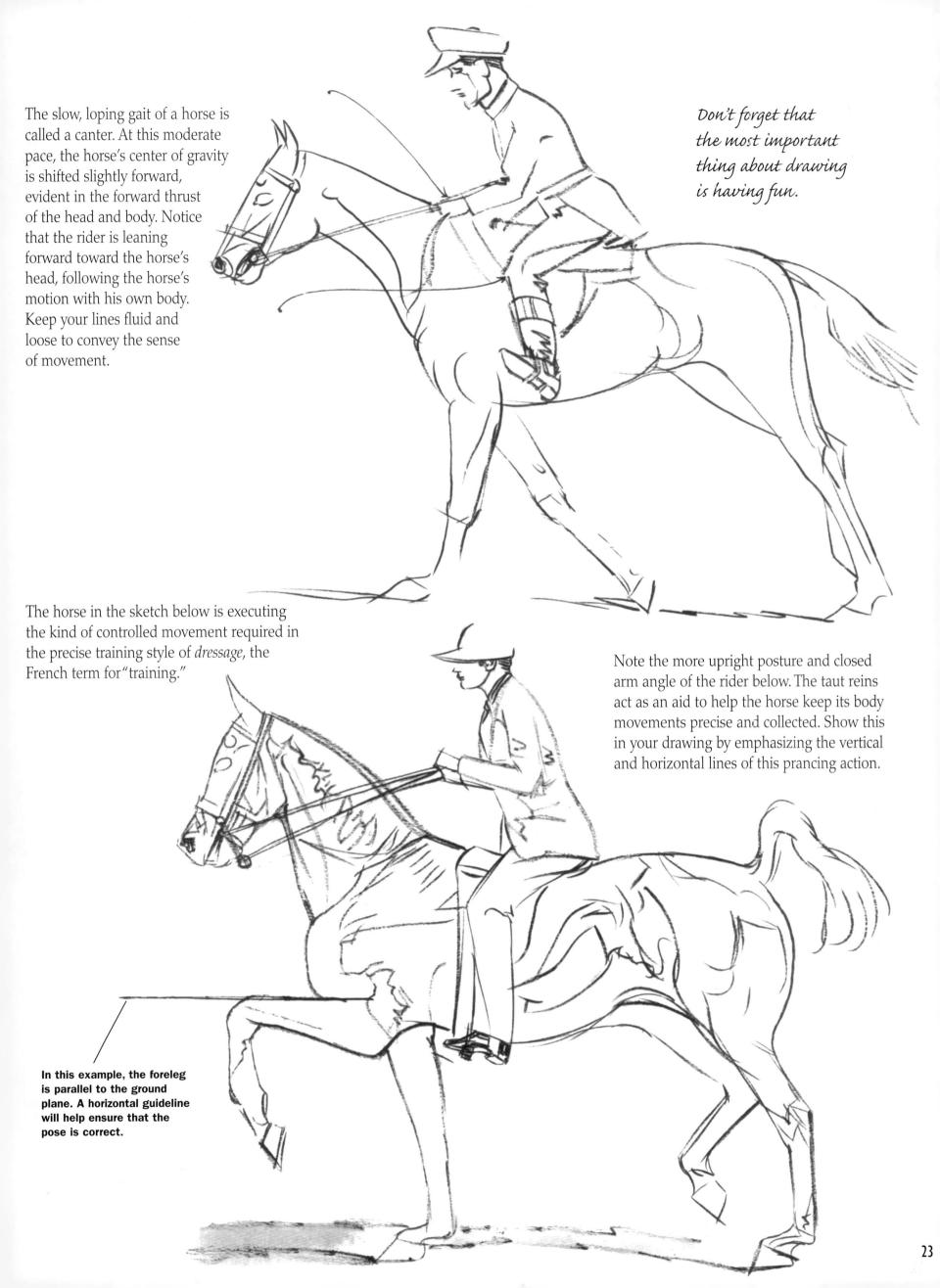

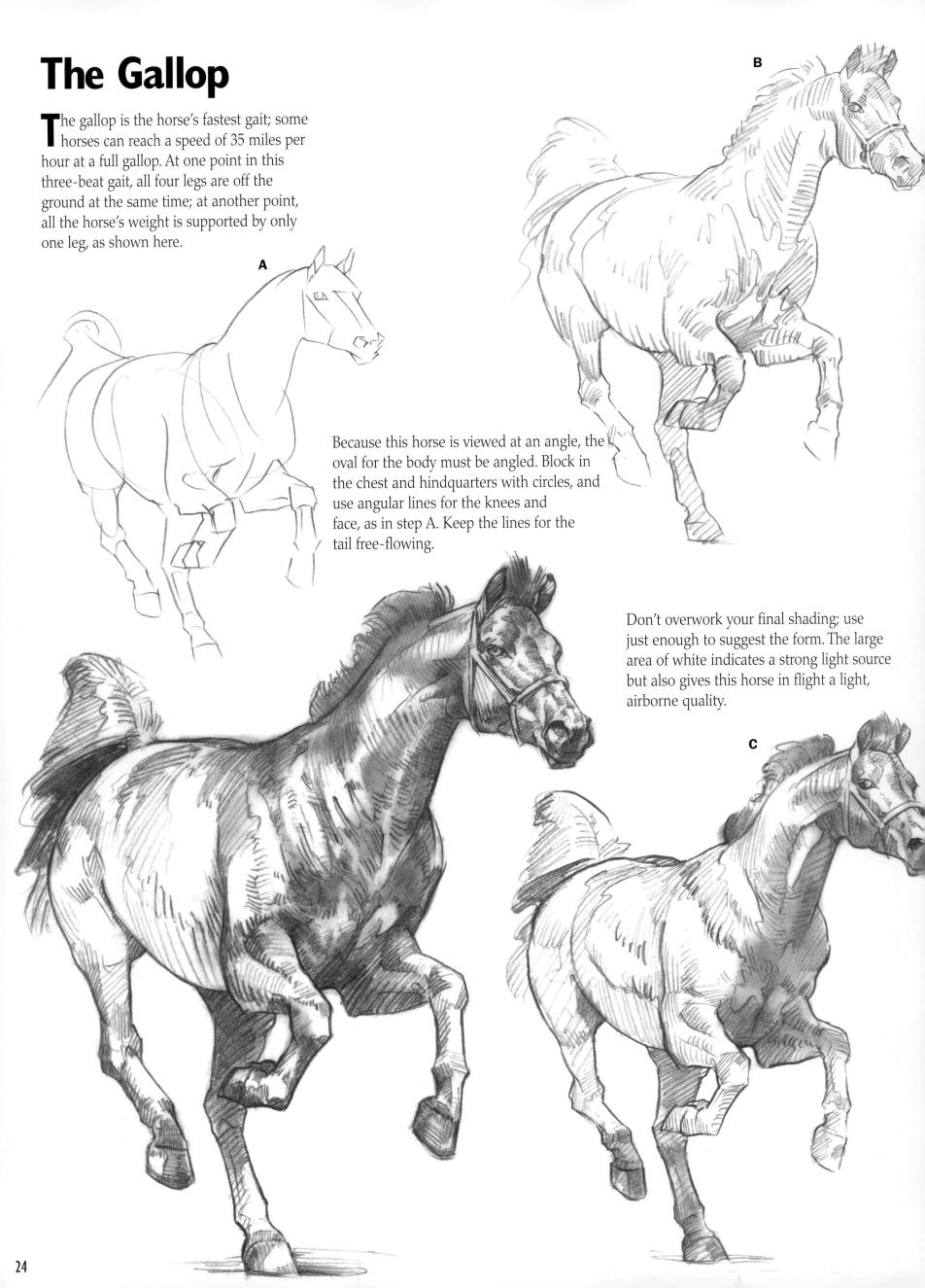

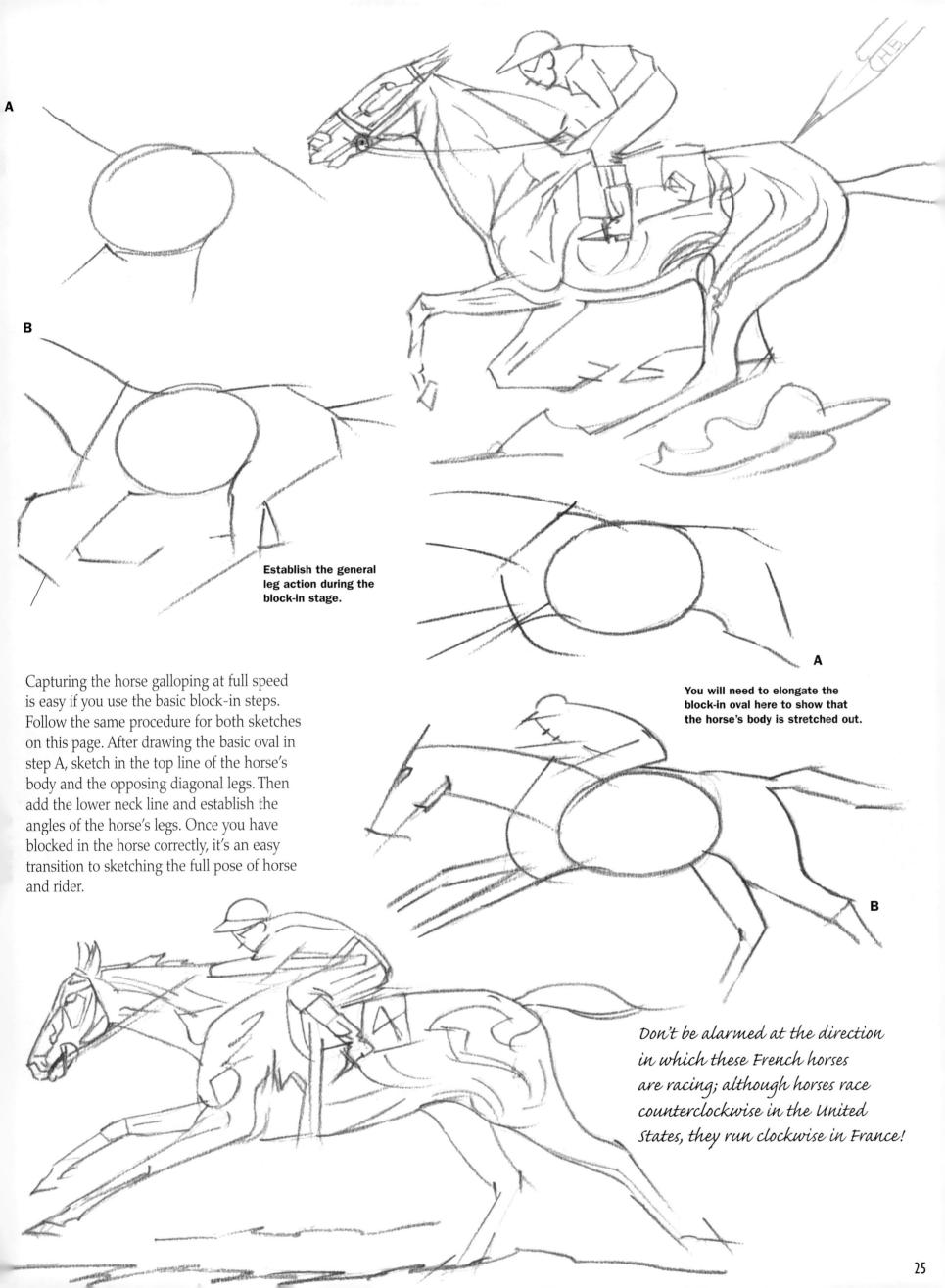

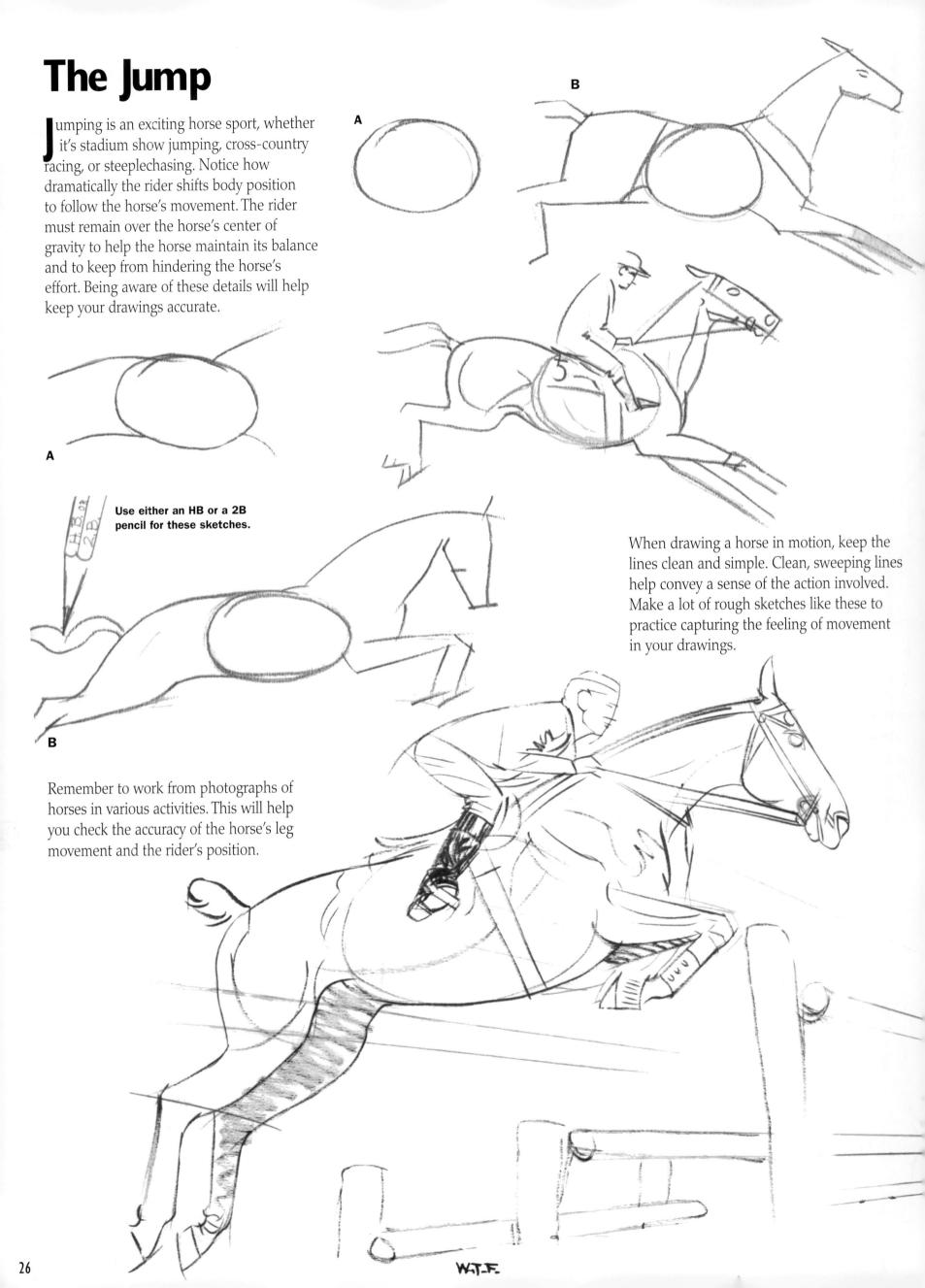

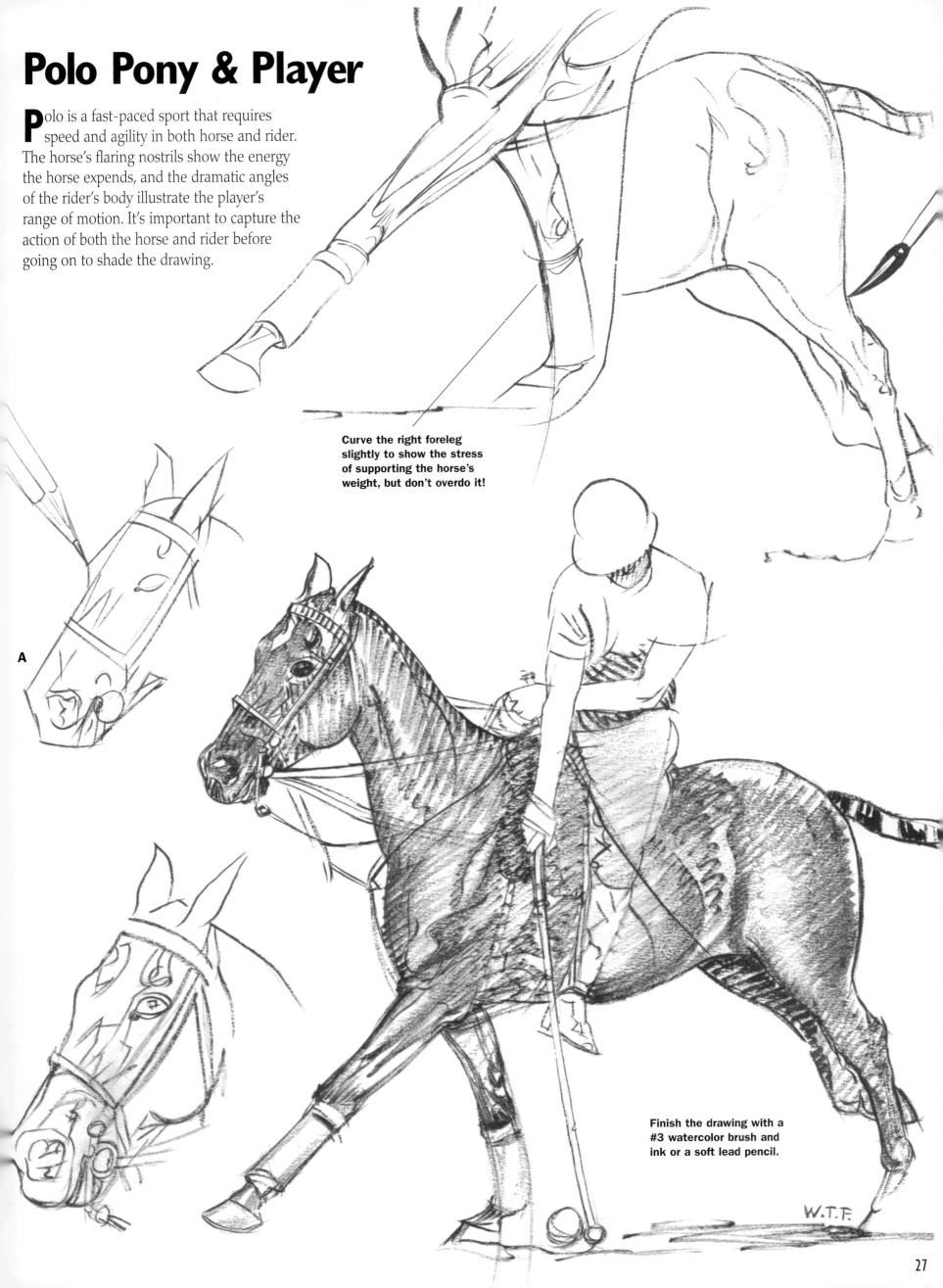

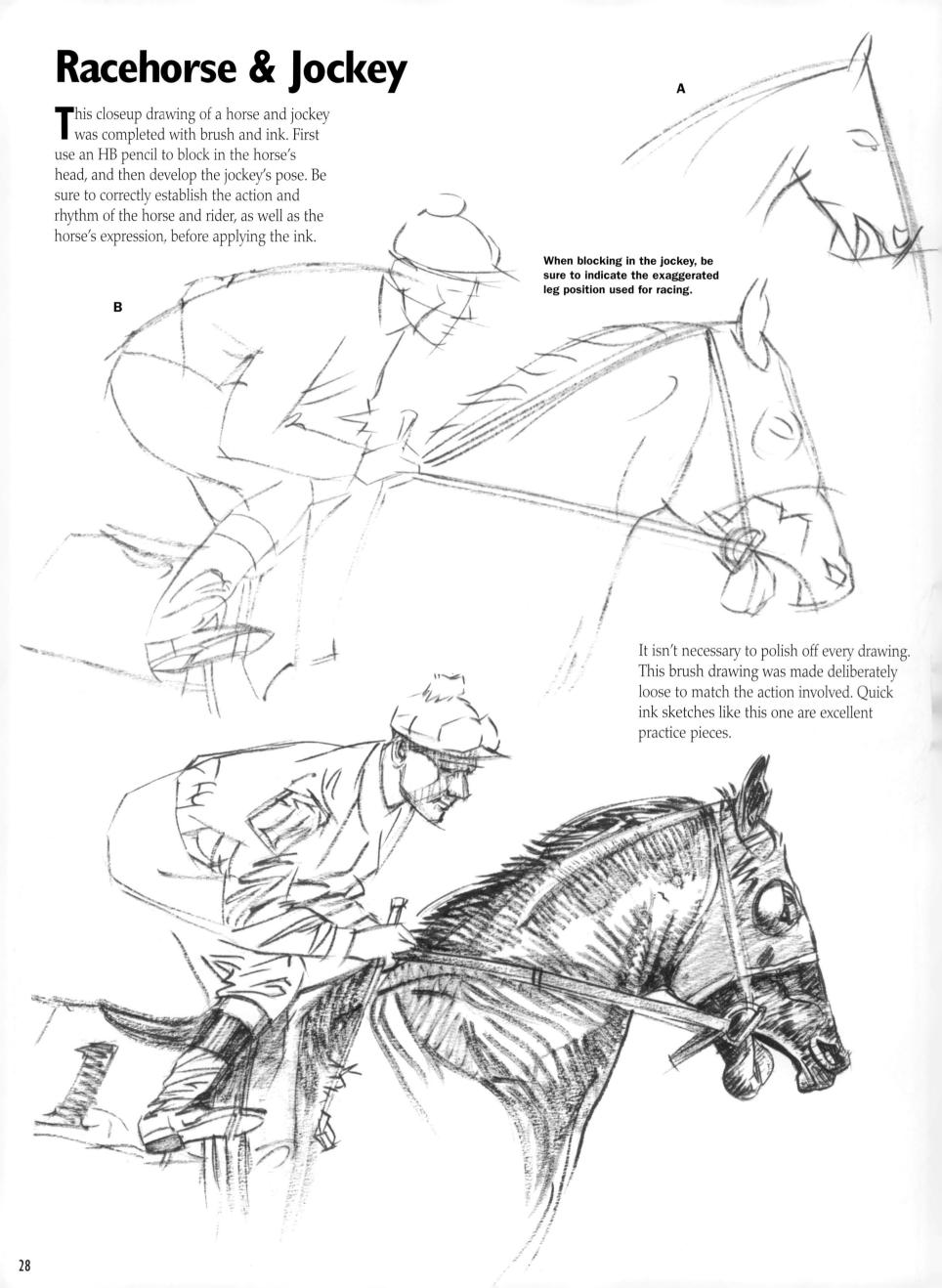

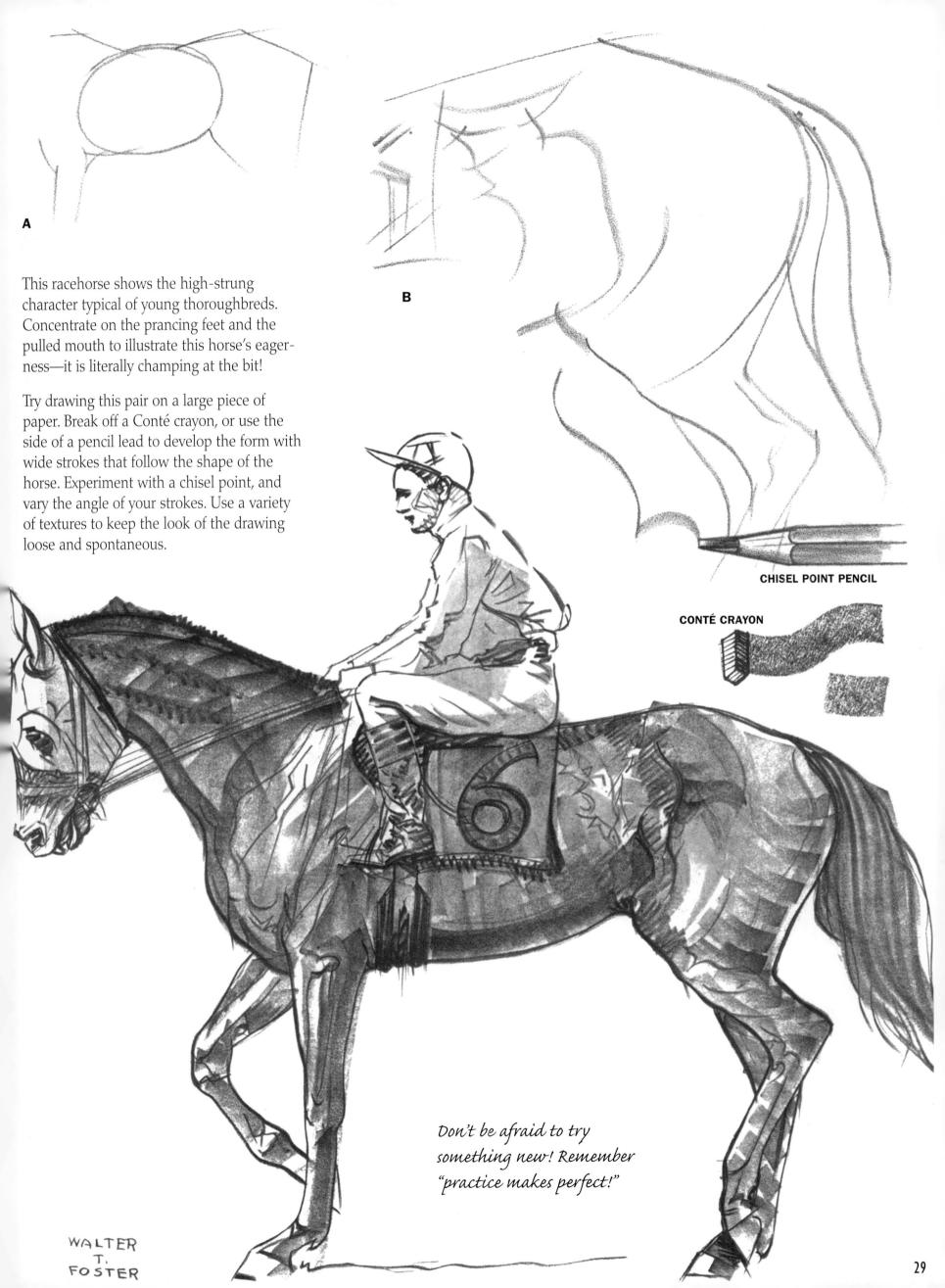

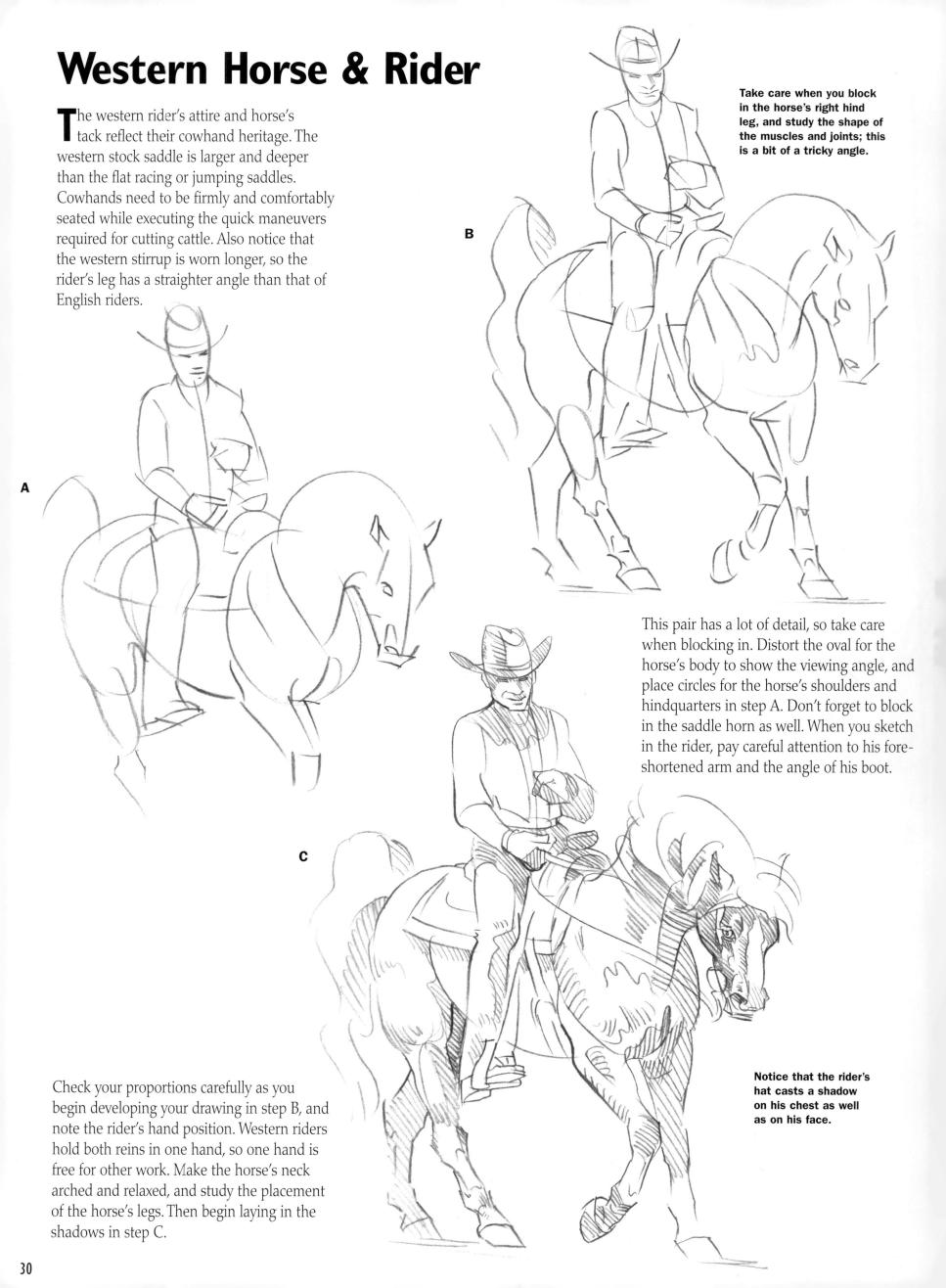

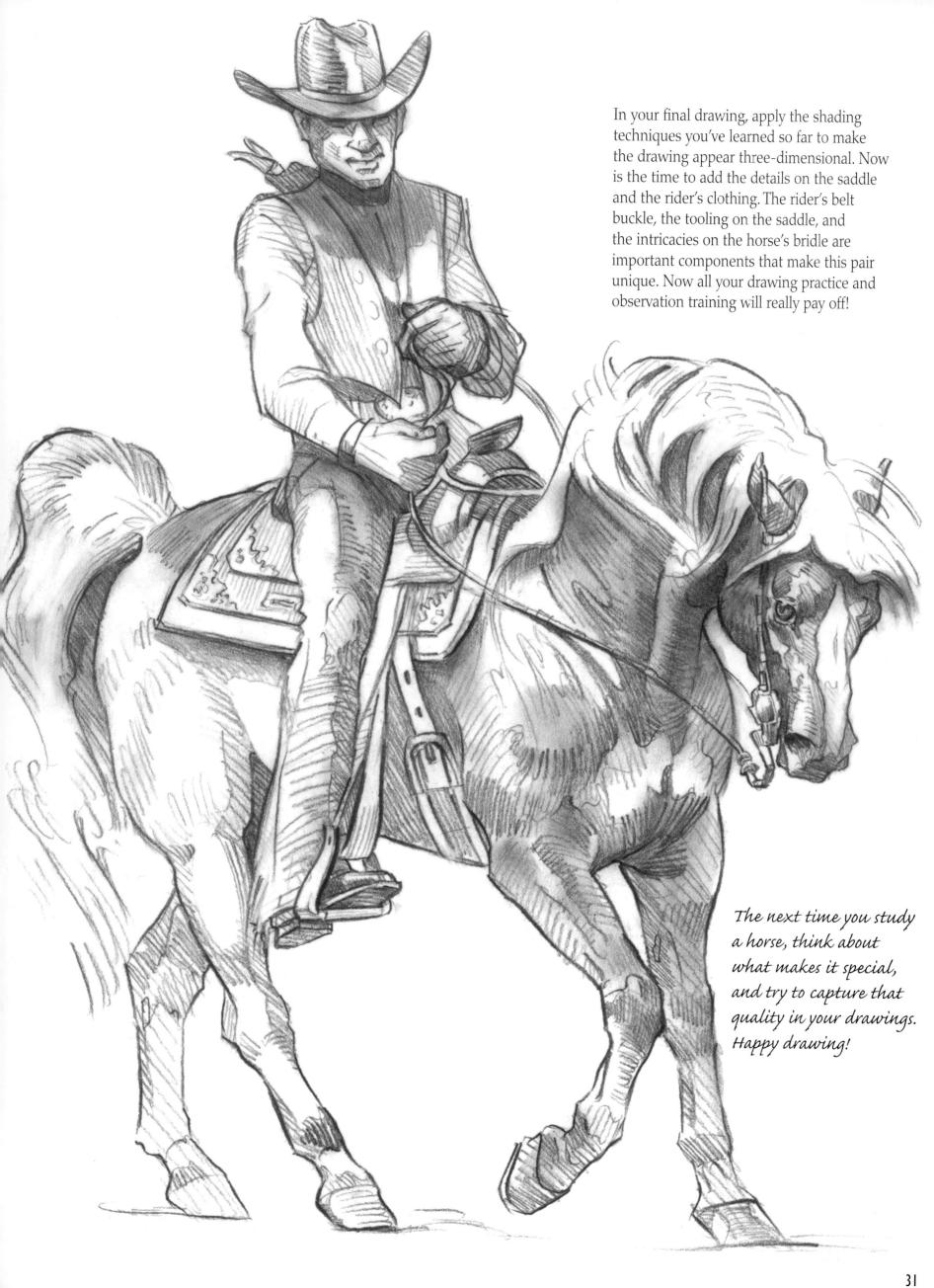

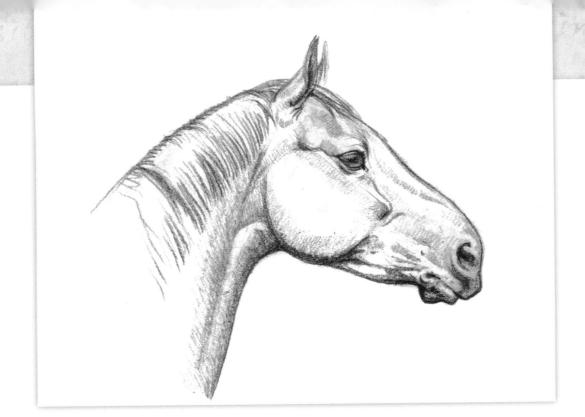

About the Artist

Walter T. Foster was born in Woodland Park, Colorado, in 1891. In his younger years, he worked as a sign painter and a hog medicine salesman. He also performed in a singing and drawing vaudeville act. Walter invented the first postage-stamp vending machine and drew political caricatures for several large newspapers. He's well known as an accomplished artist, art instructor, and art collector. In the 1920s, while running his own advertising agency and instructing young artists, Walter began writing self-help art instruction books. The books were first produced in his home in Laguna Beach, California, where he wrote, illustrated, and printed them himself. In the 1960s, as the product line grew, he moved the operation to a commercial facility, which allowed him to expand the company and achieve worldwide distribution. Walter Foster was a truly dominant force in the development of art instruction books that make it possible for many people to improve their art skills easily and economically. Walter passed away in 1981, but he is fondly remembered for his warmth, dedication, and unique instruction books.